POSTCARD HISTORY SERIES

Victorian Hartford

Hartford was settled on the shores of the Connecticut River. By 1869, the city had expanded in all directions to encompass a sizeable area. The streets, lined with an array of impressive buildings, were broad and long.

POSTCARD HISTORY SERIES

Victorian Hartford

Tomas J. Nenortas

ARCADIA

First published 2005

Published by Arcadia Publishing,
Charleston SC, Chicago IL, Portsmouth NH, San Francisco CA

Printed in Great Britain

Library of Congress Catalog Card Number: 2004113464

For all general information, contact Arcadia Publishing:
Telephone 843-853-2070
Fax 843-853-0044
E-mail sales@arcadiapublishing.com
For customer service and orders:
Toll-free 1-888-313-2665

Visit us on the Internet at www.arcadiapublishing.com

This aerial view of Hartford was taken from the lantern of the state capitol. It shows the Park River flowing beside a grand mix of buildings that made the capital city a viable and beautiful place to be.

CONTENTS

ACKNOWLEDGMENTS

All images are from the private collection of the author.

I wish to thank my parents, Vytenis and Birutė Šetikaitė, for all their unconditional love and support, which means more to me than they will ever know; my brothers- and sisters-in-law, Paulius, Mary, Edis, Asta, and Petras, for all their advice; and my nephew Adomas for putting smiles on my face.

I would like to especially thank my wife, Raminta Normantaitė, for all her patience, devotion, love, and beauty, inside and out. I could not have done this without her.

This book is dedicated to my grandparents, Konstancija Matulaitytė, Vaclovas Nenortas, Genovaitė Sriubaitė, and Antanas Šetikas. From all their wonderful stories, they instilled in me a passion and respect for family history and genealogy. Their ultimate sacrifices allowed our family to be raised in freedom. Ačiū. Thank you.

INTRODUCTION

Hartford is on the edge of an urban renaissance. More and more people are making Hartford their home. They have discovered one of Hartford's greatest assets—its historic architecture. Historic architecture is more than four walls and a roof. It includes the entire environment. Structures and the surrounding landscape are links to our past, brick by brick, tree by tree. The members of Thomas Hooker's party were the first new arrivals to settle Hartford. The Victorians acquired great wealth and created a magnificent gilded city. Later immigrants came and worked in the numerous factories. They all built vibrant communities to represent their own unique cultures.

Unfortunately, due to the passage of time and history, many of Hartford's architectural gems fell into neglect and to the wrecking ball. Were they not appreciated? Did urban renewal do more harm than good? Have 40 years of highways and parking lots left an irreversible scar on this city? These are some of the questions that many people are now trying answer. Happily, there are still wonderful examples of Hartford's Victorian architecture left to enjoy, use, and preserve. The rest are reflected only in the picture postcards and other ephemera that survived.

Although the Victorian era officially ended with the death of Great Britain's Queen Victoria in 1901, the Victorian lifestyle endured. The Great War, income tax, and time itself eventually changed their world forever. Readers will be led on a tour of Victorian Hartford and be shown what made Hartford the most beautiful and prosperous city in the days of the Victorians.

—Tomas J. Nenortas

There were many elements that made Hartford work. Trolley lines, trains, and docks, along with a police force and fire brigades, made Hartford a convenient commercial and relatively safe residential place to work, live, and visit. Perhaps some of the Victorian ideas and methods should be revisited. This view shows the West Hartford and Hartford trolley line running down Asylum Street to the heart of downtown.

One

INFRASTRUCTURE
AND TRANSPORTATION

The Hartford and New York Transportation Company's Hartford Line was located at the foot of State Street. It left Hartford for New York at 5:00 P.M. and returned from Pier 32 in the East River. A one-way ticket cost $1.50; a round-trip ticket, $2.50.

First Bridge ever built across the Connecticut River at Hartford—Opened to travel April 24, 1810—Carried away in March, 1818—A toll bridge—Looking North.

Commerce played a vital role in the early development of Hartford. Links to other parts of the state mandated the creation of roads and bridges. Shown here is the first toll bridge built across the Connecticut River.

Old Bridge Hartford, Conn.

After the bridge was destroyed in a flood, it was replaced by a covered bridge. By the time this picture was taken, the structure was showing its age. It is amazing that it held the weight of a trolley, although others were cautioned to walk their horses.

This interior view shows Yankee engineering at its best, but the bridge eventually became a firetrap.

Burning of the Old Toll Bridge at Hartford, May 17, 1895.

On May 17, 1895, the inevitable happened, and the tinderbox bridge was consumed by flames. The fire was witnessed by people for miles around, on both sides of the river.

Old Hartford Toll Bridge; burnt May 17th 1895. Hartford, Conn.

In the days after the fire, people gathered to view the smoldering ruins. The dog in this view seems unfazed by the calamity, but Hartford residents surely knew that the bridge had been a vital commercial link and had to be rebuilt.

Temporary Wooden Bridge between Hartford and East Hartford — Opened to Travel June 8, 1895 — Carried away by Flood December 23, 1895.

Incredibly, a temporary wooden bridge had been completed by the following month, but Mother Nature stepped in yet again. A day before Christmas Eve 1895, another flood carried away the new bridge.

Temporary Iron Bridge between Hartford and East Hartford, now in use — 1905 — Opened to Travel June 12, 1896.

Shaken, but resolved to prevail, Hartford's Victorians built a temporary iron bridge six months later. It accommodated horse, trolley, and pedestrian traffic.

Hartford had a centuries-old connection to the Connecticut River. To maintain this relationship, it was decided that a stone bridge was finally to be built to span the river. Notice the passenger liner docked to the right and the marvelous houseboat anchored in the middle.

The New Bridge at Hartford, Conn.

The new stone bridge took years to complete and was said to be the longest in the world at the time. This view, looking south down the river, shows that the bridge was built high enough to accommodate the tall smokestacks and masts of the ships passing through.

NEW STONE BRIDGE AT HARTFORD, CONN.—(Bird's-eye view, looking north.)—Showing in detail, on the left, the Western Approach, including the new Freight Yards, the open Railroad Tunnel, the new Boulevard to State Street, the Promenade to Riverside Park, and the proposed general treatment of the river front. Length of Bridge, about 1281 feet; width 80 feet; height at center, about 40 feet above low water. Corner stone laid April 16, 1904.

The new bridge, having been raised to create a connection to the new boulevard and to the rest of the city, also accommodated train and trolley traffic. This view looks north.

14

HARTFORD, CONN. First Car (No. 486) crossing NEW STONE BRIDGE over Connecticut River November 29 907. (Going East). (A 126)

This "chartered car" was the first to cross the new bridge, in 1907. Trolleys were a great way to commute back and forth to Hartford. Tracks were laid throughout the major streets, giving people an affordable way to traverse the ever growing city.

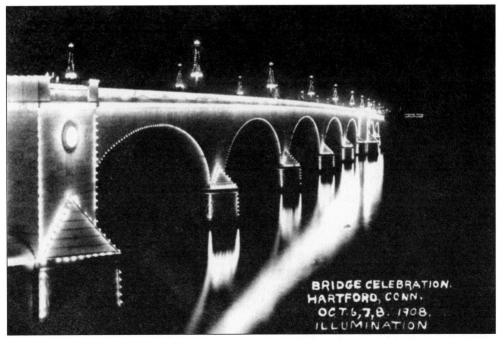

BRIDGE CELEBRATION. HARTFORD, CONN. OCT. 6, 7, 8. 1908. ILLUMINATION

The yearlong celebration of the completed bridge ended with a final dedication in 1908. Souvenirs were hawked, and citizens rejoiced and gathered for a spectacular illumination that lasted three days. The bridge still stands proud.

OLD UNION STATION, HARTFORD, RAZED IN 1886.

The railroad was also an economic link to the rest of the state and beyond. This 1849 station was demolished because the grade-level crossing was believed to be too dangerous for horses and pedestrians. However, there were never any reported fatalities.

Railway Station, Hartford, Conn.

The station was replaced by this elevated structure, which stood until a 1914 fire destroyed it. It was replicated to the nearest detail using the original plans. Union Station continues to serve passengers today.

BUILDING OF THE FOUR TRACK BRIDGE OVER THE CONNECTICUT RIVER, 1906

To help better connect the railroad to the eastern side of the state, this "four-track" iron bridge was laid across in 1906. Before the proliferation of the automobile, trains were the mode of transportation. Eventually, passengers were able to travel by train from Connecticut all the way to California.

Dock and State Street Station. N. Y., N. H. & H. R. R. Co., Hartford, Conn.

State Street led all the way down from the Old State House to the banks of the Connecticut River. There was an array of docks, warehouses, taverns, and even a hotel or two. Passengers could travel to New York either by train or steamer. This entire area was lost when a dike was constructed in the 1940s and when the interstate highway system came through 20 years later, separating Hartford's historic connection to the river.

Police Patrol, Hartford, Conn.

Throughout history, cities without law enforcement have been unmanageable. Victorians had a bit of humor regarding this notion. The reverse of this postcard reads, "This what we give the drunks a ride in around Hartford." The Victorians had to deal with social issues just as people do today.

Firefighting was highly advanced by the time this picture postcard was taken. The "Pride of Hartford" was nicknamed "Jumbo" for its great size. During practice runs and real emergencies, it was said to startle horses, and an occasional awning would catch fire as the steam-driven engine raced by.

Located on Blue Hills Avenue near Albany Avenue, this three-bay engine house was ready to respond to any emergency in this rapidly expanding section of the city.

G. Fox and Company had expanded to several buildings on Main Street by the time this fire consumed the landmark store on January 29, 1917. The store was rebuilt into one unified structure. The building still stands with new purpose on Main Street. To the far left are the Pilgard Building and the Baptist church, both of which were unaffected by the fire.

Two
GOVERNMENT, PUBLIC, AND PRIVATE STRUCTURES

Court House, Hartford, Conn.

This stately courthouse occupied the corner of Trumbull and Allyn Streets. Allyn Street used to run all the way up to Trumbull Street until the area was slated for urban renewal. This portion of the street was absorbed into the failed Civic Center, which itself is now undergoing demolition.

The state capitol is one of the finest examples of civic architecture in the country. It was built amongst great competition and disagreements between builder and architect. The building was originally designed without the cupola, but there was discussion whether a clock tower or cupola should be added. The latter won out.

A referendum had been cast to decide between Hartford and New Haven as a permanent state capital. The new capitol was constructed with the finest materials and has undergone several restorations.

New City Hall. Hartford. Conn.

406309

City hall was housed in the Old State House until funds were allocated for a new municipal building. The first section was built in 1915 and was gradually enlarged. It is an exquisite example of the Beaux-Arts style, which still gives a touch of class to Main Street.

Connecticut State Library, Hartford, Conn.

Another impressive Beaux-Arts building is the 1910 Connecticut State Library and Supreme Court Building. It complements the capitol, which is across the street on Capitol Avenue. They are neighbors still.

This "castle" was actually the second armory built in Hartford, in 1879. Designed by famed architect George Keller, it stood at 51 Elm Street. It was in fact an addition to a converted skating rink. When plans were made for an even larger third armory, it eventually ended up in the hands of the Hartford Buick Company. Unfortunately, it was demolished c. 1924.

In this view, the state capitol rises serenely above Hartford. To the right, the framework for the new Broad Street armory can be seen.

STATE ARSENAL AND ARMORY, HARTFORD, CONN.

The new armory's official address was on Broad Street, but the most impressive view was from Capitol Avenue. The Park River passed under an iron-fenced bridge, as can be seen at the lower right. The armory still graces this location.

The Armory, decorated for the Junior Promenade

The new armory was not used only for military purposes, as evidenced by this photograph. It was convenient that Hartford Public High School was located just down the street, across from the train tracks on Hopkins Street.

County Building---Hartford, Conn.

We revisit Trumbull Street to view two very different types of Victorian architecture. The simple utilitarian building on the left contrasts greatly with the ornate county building. Victorians loved to overindulge in the details when it was required and were quite restrained when it was not needed. These two examples were lost to early attempts at renewal.

The Foot Guard Armory, on the corner of Foot Guard Place and High Street, advertised itself as one of the largest rentable public halls, good for balls, fairs, concerts, lectures, and banquets. With room for 1,450 people, the armory was illuminated with both electric and gas lights. Happily, it still stands in its original location.

This wonderful mix of turrets and gables was the YMCA building, on the corner of Pearl and Jewell Streets. The valiant but unsuccessful attempts to save it led to the modern organized preservation movement in Hartford. A parking lot replaced this beauty.

Perhaps the only "misplaced" Victorian structure in Hartford was the massive post office built on the East Lawn of the Old State House. It obliterated the view the statehouse had of State Street and the Connecticut River. When it was first built, it had two large towers on either side.

The post office was even enlarged, absorbing one of the towers and adding a circular wing. Misplaced as it was, it was a grand structure. It was demolished in 1934, and the East Lawn was reestablished.

Post Office. Hartford, Conn.

Hartford, Conn. Hartford Golf Club.

Membership in the Hartford Club provided access into the Hartford Golf Club. Originating in Scotland, the game eventually came to America. The club was organized in 1896 but was actually located in West Hartford, at 1520 Asylum Avenue, west of Prospect Avenue.

Tennis was also a relatively new sport to the Victorians. It was played on grass in head-to-toe white. The tennis court at the Hartford Golf Club was the place to be and be seen by Hartford's social elite.

Hartford Club. Hartford, Conn.

Prospect Street was lined with a club, societies, and a lodge. Members were industry and political leaders of the well-to-do. The stately Hartford Club once had an elegant ballroom wing that was demolished to make way for an insurance company's expansion. Faced with rising costs and declining membership, die-hard members recently won a vote not to sell and are determined to stay on Prospect Street.

Elks' Building—Hartford, Conn.

The Renaissance Revival–style Elks Lodge was designed with beautiful interior rooms of dark woods and stained glass. Built in 1903, the lodge has also maintained a grip on its location on Prospect Street, while most of the surrounding area has fallen to the wrecking ball.

Three
BUILDINGS AND BUSINESS

Pope Manufacturing was an economic force in Hartford. From bicycles to the first automobile factories on Capitol Avenue, the company employed many of the newly arrived immigrants who settled in the Frog Hollow section of Hartford. George Keller designed the center-arched office building in the Italianate Romanesque style. These fabulous buildings that once lined the avenue did not survive past 1971.

Built originally for the Orient Insurance Company, this "jewel box" had a high dome on its roof. Although the dome is now gone, the building still stands on Trinity Street. To the left are the backs of the row houses that once stood on Elm Street.

The National Fire Insurance Company's stately building stood on the corner of Pearl and Lewis Streets. The company was chartered in 1869, with departments in Chicago, San Francisco, New Orleans, and Dallas. By 1911, it had $11 million in assets. The site is now occupied by a parking garage.

The whimsical headquarters for the Connecticut Fire Insurance Company was at 51 Prospect Street on the corner of Grove Street. The building did not survive the rapid expansion of neighboring insurance structures.

Connecticut Fire Insurance Co. Home Office—Hartford, Conn.

Hartford Fire Insurance Co.— Home Office — Hartford, Conn.

This view looking down Pearl Street shows what was advertised as Hartford's oldest insurance company, chartered in 1810. The building was located at 125 Trumbull Street. The directors of the company were from some of Hartford's oldest families, such as the Lymans, Bissells, and Goodwins. Across Trumbull Street, to the right, is the hall of records for the city of Hartford. Both structures are long gone.

These two structures replaced earlier ones that were built on Main Street. The building on the left was built for the Aetna Insurance Company. The one on the right was commissioned by the Charter Oak Life Insurance Company. Aetna began to buy up adjacent properties to consolidate its buildings. Decades later, the buildings were torn down for an elevated entrance to the Travelers building that had been built next to them.

Travelers Insurance Building, Hartford, Conn.

As insurance companies merged and grew, more space was needed. Shown here is the first-phase construction of Travelers Insurance. The space later doubled in size and took over the entire block.

The Hartford Life Insurance Company graced the corner of Ann and Asylum Streets. It was wonderfully crowned with ornate detail that wrapped around its sides.

The Hartford National Bank Building was Hartford's first skyscraper. Under protest, the entire Main Street block was demolished to make way for a modern building, which was never built.

Capitol Avenue had many factories built on it over the years to make use of the Park River that flowed through this part of the city. The Pratt and Cady Company had its iron and brass foundry at 556 Capitol Avenue on the corner of Sigourney Street.

FACTORY OF THE PRATT & WHITNEY CO., HARTFORD, CONN.

Eventually, the company expanded as Pratt and Whitney with its large complex at 1 Flower Street. The company made fixtures, small tools, and gauges for the manufacture of guns, sewing machines, and typewriters. The area has lost most of its industrial buildings in the last decades.

Frog Hollow was the neighborhood closest to the Capitol Avenue factories. Here, thousands of new immigrants settled and worked in the ever expanding factories. The Billings and Spencer Company was actually located inside Frog Hollow on the corner of Lawrence and Russ Streets. It was converted for residential use.

E 9740 The Hartford Rubber Works Co., Hartford, Conn., U.S.A.

To meet demand for the bicycle and automobile industries in Hartford, the Hartford Rubber Works had a factory at 691 Park Street in the Parkville neighborhood. The company also produced syringes, water bottles, and even fruit jar rings.

This 71–93 Albany Avenue business billed itself as "Connecticut's most Modern and Progressive Bakery." It supplied breads, pies, cakes, and cream goods. Notice, however, the use of horses hitched to wagons and only one truck lined up for daily deliveries.

Hartford was the place to go for shopping. People from near and far came here to pick up the latest fashions, especially on Asylum Street, which was lined with stores that met the needs of every consumer.

This importer was located at 32–42 Market Street in the Front Street neighborhood. Apparently, "jobbers" was a Victorian term for whitewashers, but what coffee had to do with painting is a curiosity.

One Block from Union Depot, Hartford, Conn. The Largest Garage Between New York and Boston.

With the popularity of automobiles rising, people needed places to store them in the city. The Miner Garage Company had room for 200 automobiles. It was at 164 Allyn Street on the corner of High Street. It is ironic that when attempts to revitalize the area failed, the neighborhood was demolished for parking.

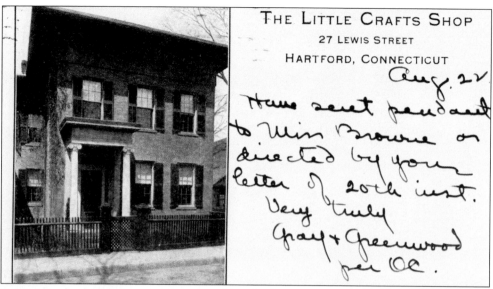

THE LITTLE CRAFTS SHOP
27 LEWIS STREET
HARTFORD, CONNECTICUT

Aug. 22

Have sent pendant to Miss Browne or directed by your letter of 20th inst.
Very truly
Gray + Greenwood
per OC.

Lewis Street is perhaps the most charming of Hartford's streets. With only a handful of mid-19th-century buildings left, the street now has two massive parking garages on both corners of Lewis and Pearl Streets. The building at 27 Lewis Street still stands but is being incorporated into a new residential development.

COOMBS, LEADING FLORIST, HARTFORD, CONNECTICUT

Coombs Leading Florist was the place to go for the freshest flowers. The store was located at 688 Main Street, and the greenhouses were on Benton Street, next to the Old South Burying Ground. Floral decorations for weddings, dinners, and parties were "executed in a most artistic manner."

Pope Manufacturing was a leader in the automobile and bicycle industry in Hartford and the region. If you could not afford one of the new Pope automobile series, perhaps a new Columbia model would better suit your budget.

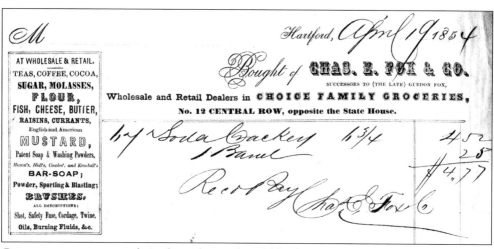

Grocery stores were a staple in themselves and could be found throughout the city. Over time, the ones downtown disappeared completely. Happily, they are making a slow comeback as more people are rediscovering the attractions of living downtown once again.

UMBRELLA AND PARASOL DEPARTMENT.

SAGE, ALLEN & CO.

It would have been a Victorian faux pas for any lady to be caught without her parasol in polite society. Sage Allen and Company had a wonderful selection for sale in its umbrella and parasol department.

Four

FAITH AND RELIGION

Park Congregational Church was on the corner of Asylum and High Streets. The 300-member church was organized in 1824, and this edifice was dedicated on March 29, 1867. Plans included a steeple that was never built. The church was sold and, in 1926, was replaced by the Capitol Building, now known as 410 Asylum Street.

Synagogue of the Congregation Beth Israel — Hartford, Conn.

By 1911, Hartford had over 110 places of worship across the city. The writer of this postcard pokes fun at this fact: "Lots of churches here, either the people must be very bad or very good." The writer also misidentified this as a church when it actually was the synagogue of the Congregation Beth Israel, which was organized in 1847. The synagogue was erected in 1876 and enlarged in 1898. It has been converted for community uses.

This imposing building is the Mount St. Joseph Seminary, located on Hamilton Avenue in the suburb of West Hartford in the Hamilton Heights section of town. It was owned and run by the Mount St. Joseph Convent Corporation.

The Theological Seminary, at 1507 Broad Street, across the street from Hartford Public High School, was a handsome building. It was built for the needs of an association of Congregational ministers. It held a library of over 94,000 volumes; a chapel; music, reading, and lecture rooms; 60 students' rooms; and a fully equipped gymnasium. The building has not survived.

Theological Seminary, Hartford, Conn.

What had been the Henry Barnard House on Main Street was converted to the Holy Ghost Provincial House and St. Elizabeth's Home. An extensive addition to the back of the house contained rooms for residents and a pleasant little chapel. The complex today serves those who are less fortunate.

Chapel Saint Elizabeth's Home, Hartford, Conn.

The cornerstone for St. Joseph's Cathedral was laid on April 29, 1877. The cathedral was consecrated on May 8, 1892. It stood towering over Farmington Avenue until it burned on December 31, 1956. Unfortunately, it was decided not to rebuild according to the original plans. All accompanying structures, including the lovely convent, were eventually demolished as well.

St. Peters Church, Hartford, Conn.

St. Peter's Church was built around a schoolhouse in 1865. Measuring 70 by 164 feet, it was one of the largest churches in the state. This irreplaceable structure cost $200,000 to build and continues to serve its members today.

INTERIOR OF ST. PETER'S CHURCH HARTFORD CONN.

The North Methodist Episcopal Church was built in 1873 at 313 Windsor Avenue next to Spring Grove Cemetery. Under new guardianship, the structure still stands. Notice the handsome house next door. In 1917, it was home to the Jeremiah O'Callaghan family.

North Methodist Church. Hartford, Conn.

Windsor Avenue Congregational Church. Hartford, Conn.

Diagonally across the street at 300 Windsor Avenue was the Windsor Avenue Congregational Church. Organized in 1870, it had a 960-volume library and a Sunday school.

51

Asylum Hill Congregational Church, Hartford, Conn.

On June 15, 1866, the Asylum Hill Congregational Church was dedicated. It was built of Portland brownstone. A parish house addition was built in 1903. Rev. Joseph Twichell, the pastor, was a good friend of Mark Twain. The building is currently undergoing an extensive restoration.

Victorians also preserved their past with the 1827 South Congregational Church, on the corner of Main and Buckingham Streets. It was rebuilt after a fire and has had a large addition put on. The arched-windowed building on the left was replaced by a large brick apartment building, which was torn down to build an even larger one.

South Congregational Church — Hartford, Conn.

This Congregational church moved to more fashionable Farmington Avenue after its Pearl Street location was sold and torn down. The 1899 church still anchors the corner across from Nook Farm.

791 CENTER CHURCH, First Church in Hartford Conn.

Another church well preserved by Hartford's Victorians was Center Church. Built in 1807, it was surrounded by buildings until a 1900 effort opened it up on Main Street.

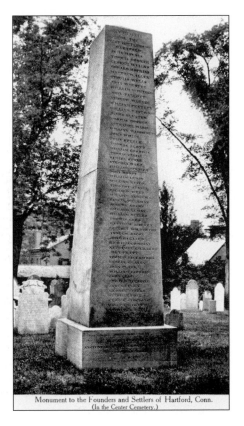

Monument to the Founders and Settlers of Hartford, Conn.
(In the Center Cemetery.)

A monument was erected to the original founders and settlers in the Old Burying Ground, next to Center Church. It was made of brownstone and, because of weathering over time, had to be replaced.

The cemetery was also encroached upon by buildings. When the Waverly Building was built on Main Street, it was said workers dug up old bones. What happened to the remains is unknown.

Located near the intersection of Fairfield and Maple Avenues, the entrance to Cedar Hill Cemetery was designed by George Keller. The 1875 superintendent's house, on the far right, is still used for its original purpose.

When the Old Burying Grounds and cemeteries were filled, a new location was selected on the outskirts of the city. The parklike Cedar Hill Cemetery was planted with rare trees and shrubs. Many members of Hartford's leading families were buried here, but as noted in the description, "in laying out lots and fixing prices the wants of all classes have been considered."

Five

INSTITUTIONS, HOSPITALS, AND EDUCATION

Hartford Orphan Asylum.—Hartford, Conn.

The intimidating Hartford Orphan Asylum was a tremendous place on top of a hill on Putnam Street. It had fine vistas of the city below it. Although the orphanage was demolished, it is fitting that a school was constructed on its grounds.

The Almshouse was also a forbidding place, located on the curve where Vine Street turned into Holcomb Street, north of Keney Park. It was a place for those less fortunate and served for a time as a city hospital.

THE HILLCREST, INC., 312 FARMINGTON AVE., HARTFORD, CONN.

A HOME FOR CULTURED PEOPLE

This "home for cultured people" was actually a home and conservatory for musicians. It offered beginners', teachers', and artists' courses in the vocal, pianoforte, and violin departments.

Retreat for Insane. Hartford Conn.

The Retreat for the Insane had a large campus of Victorian buildings. Many of the original buildings survive. The grounds were beautifully planted, and a large number of rare specimens are still an attraction today.

Deaf and Dumb Asylum. Hartford, Conn.

Asylum Street was named for the Deaf and Dumb Asylum, which was built on this stretch of road near the intersection with Farmington Avenue. The territory contained several buildings and was adjacent to the Hartford Reservoir. The buildings were torn down when the land was sold, and the school moved to West Hartford.

Located on Albany Avenue in West Hartford, this home for the elderly was almost symmetrical in form except for the slight variations in the two towers.

Victorian children never relished the idea of spending their entire summer vacation in summer school—a perspective surely held by most children today. However, this outdoor school, with its lounge chairs and plenitude of shade, was perhaps not that bad.

St. Francis Hospital, on Woodland Street, was one of Hartford's first hospitals. It employed the latest technologies, and windows were elongated to provide an abundant amount of light during surgeries.

Today's health regulations would not allow this, but back then, fresh air was considered a cure-all for all types of ailments. Cribs were attached to rods and placed precariously on the tops of tables.

Nurses Home. Hartford, Conn.

The Nurses Home was located at 37 Jefferson Street on the grounds of Hartford Hospital. Nursing was as noble a profession then as it is now.

Another home for the aged was the Old Folks Home, located at 36 Jefferson Street across the street from Hartford Hospital. It opened in 1884. Requirements for admission were that "applicants be citizens of Hartford County, of good character, not under sixty years of age, and in reduced circumstances."

215799

Hartford Hospital, built at a cost of $244,000, was dedicated in 1859. Most of the money was donated by individuals except for $50,000 granted by the state. The hospital has greatly expanded over the years and has maintained a strong commitment to Hartford and the region.

Hartford Hospital. Hartford, Conn.

Name

Street

City

State

Walnut Lodge Hospital, at 56 Fairfield Avenue, was a private hospital for the special treatment of "alcohol and opium inebriates." It was located near the outskirts of town. Privacy allowed for confidentiality and respite.

WALNUT LODGE HOSPITAL Inc.,
T. D. CROTHERS, M. D., SUPT. HARTFORD, CONN.

Flyers, pamphlets, and advertisements were taken out in the local directories. Cards like this one were handed out and, if not wanted or needed, were asked to be passed along to one who might benefit from treatment.

MORSE BUSINESS COLLEGE. ACTUAL BUSINESS PRACTICE DEPT., HARTFORD, CONN.

The Morse Business College was founded in 1860. Some of the most successful Hartford business leaders were graduates of the college. Commercial and shorthand courses were offered. This photograph illustrates the entrance of women into the work force.

LaSalletts College was a missionary college located at 85 New Park Avenue. It grew to such extents that wings were added on each side, doubling its size. With a new "mission," it still stands on New Park Avenue.

Hartford Public High School, located on Hopkins Street, replaced the school that burned on January 24, 1882. This new building, built in stages, was occupied by 1884. It was an incredible building of marble, brick, and brownstone. Its towers could be seen from many parts of the city. It was demolished when Interstate 84 was designed going straight through the landmark school.

WADSWORTH STREET SCHOOL—HARTFORD, CONN.—South School District

Hartford had some of the most beautiful school buildings in the country. The Wadsworth Street School was a three-story fireproof structure that contained 45 schoolrooms. It was torn down, and a low-income housing development was built on the site.

The Arsenal School, Hartford, Conn.

The Arsenal School, at 180 Windsor Avenue, cost $30,000 to build (including the cost of the land). In 1886, an additional two-story building was built next door for $16,500. Six years later, a kindergarten building was added to the campus.

Hartford, Conn. Northwest School

The North-West School stood at 684 Albany Avenue. First occupied in 1870, the school accommodated 100 students. Through numerous additions, the school had room for 1,000 students by 1906.

Second North School, High Street, Hartford, Conn.

The building at 249 High Street was home to the Second North School. It was erected in 1891 with 15 rooms and accommodated 700 pupils. The library contained 1,800 books. Efforts are being made to save this now boarded-up school from further deterioration.

Wethersfield Ave School, Hartford, Conn.

The school at 291 Wethersfield Avenue was opened in 1883 at a cost of $25,000. Made of brick and stone, it had 19 rooms and space for 850 students.

Southwest School, White Street, Hartford, Conn.

Built in 1902, this was one of Hartford's smallest schools. The four-room school cost $15,000 and was on White Street.

Brown School. Hartford. Conn.

The Brown School, on Market Street, was made up of several buildings and an annex built in 1897. The main school building was constructed in 1868. The entire territory was eventually demolished for a parking garage.

Washington Street School, Hartford, Conn.

The Washington Street School was at the intersection of New Britain Avenue and School and Washington Streets. It was a simple but elegant building that suited students well.

WEST MIDDLE SCHOOL—ASYLUM AVENUE—HARTFORD, CONN.

This wonderful geometrically patterned school was at 927 Asylum Street. It was occupied in 1873. The building and land cost $154,000, an incredible sum in those days. It was perhaps the best example of Hartford's Victorian school architecture.

Trinity College moved to its present location after selling its former campus above Bushnell Park to the state as the site for the new state capitol. Ground was broken in 1875 for its new 80-acre campus off Summit Street. It is said to be one of the finest examples of the English Secular Gothic style in the country.

A 7120 Gymnasium and Alumni Hall, Trinity College, Hartford, Conn.

A gymnasium and alumni hall were constructed on the Trinity College campus. The gymnasium met students' needs for athletics and was a place for graduates to gather.

Class Day at Trinity College—Hartford, Conn.

People have gathered for Class Day along the western side of a projected great quadrangle more than 600 feet in length.

73

This architect's rendering shows what Trinity would have looked like if all expansion plans had gone through. It was an imposing and awesome vision.

The back of the sketch gives the dimensions of the proposed buildings. Maps of the day even pictured a completed Trinity College before construction ever began. For one reason or another, the plans were greatly scaled back.

Six

MEMORIALS, MONUMENTS, AND A MUSEUM

Keney Memorial Tower was built on the corner of Main and Ely Streets. It is a 130-foot tower of brownstone dedicated to the memory of Walter and Henry Keney's mother. The Keney homestead and store used to occupy the land. It still shines as a beacon of Victorian architecture.

The Old Charter Oak. Fell Aug. 21, 1856. Hartford, Conn.

In 1686, an attempt was made by the English to revoke the Connecticut charter granted in 1661. When a representative came to retrieve the document, it disappeared during the meeting and was hidden in this oak tree, which stood until it was blown down in an 1856 storm.

The Old Charter Oak. Fell Aug. 21, 1856.
Hartford, Conn.

Everything was made from the wood of the fallen landmark, from the smallest souvenirs to pieces of furniture. A memorial was built in 1907. The actual spot was where the house on the right was built. Charter Oak Place was lined with large homes, many of which still survive.

The Civil War affected many families in Hartford. This monument was built on the grounds of the state capitol. It still stands as a reminder to the horrors of war.

The Soldiers and Sailors Memorial Arch was another Civil War monument that was built on Trinity Street. Construction began in 1884. A grand dedication ceremony took place on September 17, 1886. It commemorated Hartford's involvement in the Civil War. George Keller, the architect who built many of Hartford's landmarks, had his ashes buried in the east tower. The Park River once flowed under the bridge until the river was buried in a 1940s flood-control project. The bridge's arches can still be partially seen.

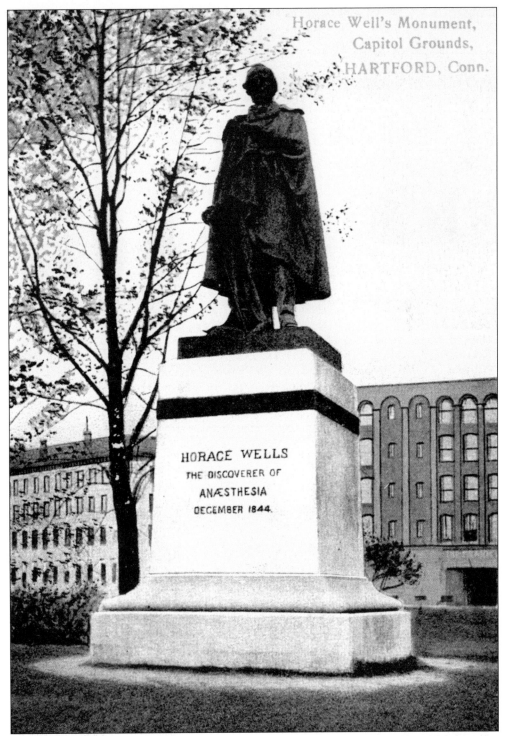

Horace Well's Monument,
Capitol Grounds,
HARTFORD, Conn.

HORACE WELLS
THE DISCOVERER OF
ANÆSTHESIA
DECEMBER 1844.

Horace Wells discovered anaesthesia in 1844. The monument to this man and his great discovery was erected in Bushnell Park. Behind the statue were the Plimton and Hills and Jewell Belting factories. The statue still remains in the park.

The Wadsworth Atheneum is the oldest public art museum in the country. It was built on land given by the Wadsworth family in 1844. It is in the Gothic Revival style and in the beginning housed a library and historical society.

Morgan Memorial, Hartford, Conn.

A center addition was the 1906 Colt Memorial Wing. It was a bequest of Elizabeth Colt. In 1910, financier J. P. Morgan, a Hartford native, provided funds for the large Morgan Memorial Wing.

Seven
GRAND HOTELS

The Garde Hotel stood at 370 Asylum Street on the corner of High Street. It was one block from Union Station and could accommodate 500 guests. It advertised the most modern conveniences, hot and cold running water, 80 private baths, and even a long-distance telephone in every room. It overlooked Bushnell Park until 1973.

THE COMMERCIAL MAN'S HOME. HARTFORD, CONN.

Touted as the "Commercial Man's Home," the New Dom Hotel, at 305 Trumbull Street, catered to the businessman's every need. A Hotel Sheraton was later built on this site.

Farmington Avenue Hotel — Hartford, Conn.

The Farmington Avenue Hotel stood at 57 Farmington Avenue on the corner of Flower Street. It was a convenient trolley ride down to Union Station or to the downtown shopping district.

The Highland Court Hotel was on Windsor Avenue opposite Belden Street. The suites were five to seven rooms large with private baths finished in marble. Furnished apartments could be let by the day or year.

The American Hotel was located at 103 State Street on the corner of American Row. With its many balconies, it was a perfect place for watching all the activity on the busy streets below. The large neighbor to the left was the post office. Nothing in this view remains.

The address for the Hotel Heublein was 98 Wells Street. The hotel was surrounded on three sides by Gold, Wells, and Mulberry Streets. From its windows, it had a fine prospect of Bushnell Park.

The Hotel Heublein's views of the park were complemented by easy access across a wooden bridge. Mulberry Street was to the right of the hotel, with the Wadsworth Atheneum visible on Main Street. The wonderful turret and rooftop terrace came crashing down with the rest of the hotel and block in 1965 to make room for a residential tower made of concrete slabs. Mulberry Street was lost forever.

HARTFORD, CONN. Hotel Heublein.

HARTFORDS NEWEST AND MOST COMPLETE HOTELS

HOTEL BOND
OPENED 1913

HOTEL BOND ANNEX
OPENED 1914

FIREPROOF
—
EUROPEAN PLAN.

HARRY S. BOND,
MANAGING DIRECTOR.

RATES: $2.00 $2.50 $3.00

RATES: $1.00 $1.50 $2.00

HARTFORD, CONN.
THESE HOUSES COMBINED MAKE THE LARGEST HOTEL IN NEW ENGLAND OUTSIDE OF BOSTON

Hotel Bond, Hartford, Conn.

One of the last hotel complexes built in the waning years of the Victorian era was the Hotel Bond. The main Hotel Bond was opened in 1913, and an annex followed in 1914. It offered the best of services to guests and their visitors.

The Bond had a café, a dining room, a rathskeller, a kaiser-keller, and a banquet hall. With so many conveniences and rooms, the hotel was advertised as the "largest hotel in New England outside of Boston."

RESTAURANT, BOND ANNEX, HARTFORD, CONN.

HOTEL HARTFORD—Hartford, Conn.—W. S. Edminster, Proprietor.

The Hotel Hartford was at 159 Allyn Street on the corner of High Street. It had 130 rooms with steam heat and electric lights. An automobile garage was across the street to provide secured parking. It went through several name changes before becoming a member of the Bond family of hotels known as the Hotel Bondmore.

This 300-guest hotel, at 152 Asylum Street on the corner of Trumbull Street, was one of the oldest in Hartford. It cost $1.50 to $3.00 per day to stay there. Guests were picked up at the train station in a gasoline-powered bus. The hotel was demolished for the ill-fated Civic Center.

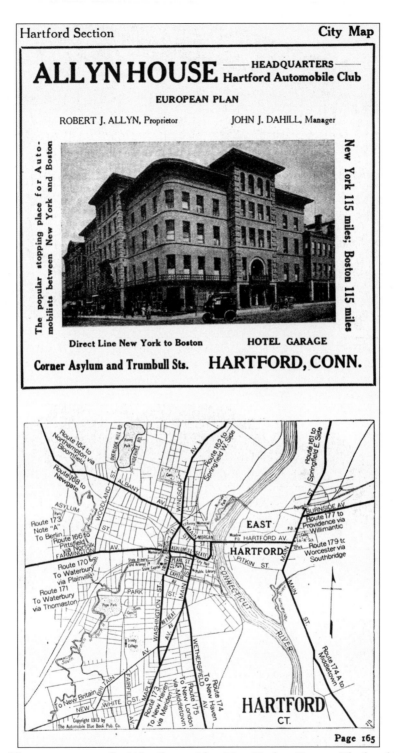

The Allyn House was supposedly 115 miles to either New York or Boston. The hotel had many famous clients, including Abraham Lincoln, who came to deliver a speech to the good citizens of Hartford.

MR. AND MRS. I. WISE,

MR. AND MRS. R. SMITH,

MR. AND MRS. J. STERN,

MR. AND MRS. S. WOHL,

MR. AND MRS. G. OLSCHEFSKIE,

MR. AND MRS. S. YOUNGMAN,

MR. AND MRS. M. WISE.

MR. AND MRS. WILLIAM WALTER,

MRS. D. ENGEL,

L. YOUNGMAN,

EX-MAYOR ALEXANDER HARBISON,

RUFUS H. JACKSON,

HARRY R. WILLIAMS,

ISAAC A. ALLEN, JR.,

V. F. SANO,

DAVID E. BERNARD,

A. M. SANO,

MISS E. B. KALISH,

S. L. BACHARACH,

H. ASHEIM,

CHARLES M. CHAMBERLAIN.

Dining was an art form in Victorian days. The many courses were carefully chosen, beverages

Menu

CLOVISES Cocktail

CRÊME DE TOMATO AU CROUTONS Sherry

OLIVES RADIS

SAUMON DE KENNEBEC A L'HOLLANDAISE Sauterne

FILET DE BOEUF PIQUE AUX CHAMPIGNONS Claret Cup

PUREE DES POMMES DE TERRE HARICOT VERTS PANACHE

PUNCH A LA COMMISAIRE WISE

POULET DE GRAIN GRILLÉ Champagne

POIS NOUVELLES POMMES A LA BOMBE

SALADE D'HOMARD EN MAYONNAISE

GLACE A LA VANILLE GATRAUX ASSORTIS

FROMAGE DE ROQUEFORT

CAFE Cigars

were of the perfect vintage, and the guest list was just right.

AUF WIEDERSEHEN.

DINNER
IN HONOR OF

Isidore Wise AND *Robert Smith*

On the occasion of their departure for
EUROPE.

ALLYN HOUSE
HARTFORD, CONN.
JUNE 15TH 1902.

TENDERED BY
G. OLSCHEFSKIE, JR.
S. YOUNGMAN.
S. WOHL.

This particular dinner was held in honor of two of Hartford's leading businessmen at the Allyn House on the occasion of their departure for Europe.

Eight

THE COLT EMPIRE
AND NOOK FARM

A 1768 Mrs. Sam'l Colts Residence, Hartford, Ct.

Samuel Colt amassed a fortune in the production of guns at his Hartford armory. From this wealth, he and his wife, Elizabeth, built Armsmear on Wethersfield Avenue in 1857. The mix of different architectural details and styles made the mansion stand out among its neighbors. Elizabeth Colt's will stipulated that her home was to be used by the widows of Episcopalian ministers and that the grounds were to be turned into a park. The grand home still graces Wethersfield Avenue.

The Armsmear estate contained hundreds of acres from the avenue to the shore of the Connecticut River. There was an entire armory village of factories and workers' housing. There were lakes, formal gardens, and greenhouses, which provided fresh flowers all year long.

The Colt Memorial Monument depicts Samuel Colt as a boy coming up with the idea for the revolving pistol and then as a successful entrepreneur. The plaques commemorate his presentation to the Russian Court and his address to English lawmakers. He built a huge empire but died young, still full of ideas.

Published by The Chapin News Company (Incorp.), Hartford, Conn.-Leipzig-Berlin

No. 764

Colt Memorial. Hartford, Conn.

The Colt wealth did not offset the tragedies in their lives. Samuel Colt died early, and only one son lived into adulthood. His son Caldwell also died unexpectedly. His mother, now all alone, commissioned this parish house as a memorial. It was built in 1896 and represented elements of Caldwell's life. The intricate tower was said to have represented a ship's mast since he had been such an avid yachtsman. The memorial still stands, but it has lost the roof detailing and tower.

View in Colt Park, Hartford, Conn.

The estate gardens were filled with imported marble statuary. They reflected nicely in the waters surrounding them. What became of them when the estate was turned into a park is unknown.

2548

With exotic plantings, lush landscapes, and fountains, the Colt estate was the premier estate in all of Hartford. People came to see how the wealthy lived, and they enjoyed the exquisite gardens before they were lost forever.

Scene in Colts Memorial Park. Hartford, Conn.

2545

Unfortunately, the integrity of the estate grounds was compromised over the years by the addition of buildings next to the mansion. The lakes were filled in, greenhouses torn down, and the statues carted away. Not much of the original Colt estate grounds can be seen today, but the land is enjoyed by the public as Colt's Park.

View in Colt's Park, Hartford, Conn.

97

The sheer size of Coltsville was in great contrast to the smaller, literary neighborhood known as Nook Farm. Here, writers and publicists settled along a "nook" in the Park River. This 1881 Queen Anne mansion is known as the Day-Chamberlin House. It was built on Forest Street and saved from demolition by the grand-niece of Harriet Beecher Stowe.

Residence of Harriet Beecher Stowe. Hartford Conn.

Harriet Beecher Stowe, author of *Uncle Tom's Cabin,* and her family moved into this 1871 house in 1873. They lived here for many years. When the area was threatened with demolition, Stowe's grand-niece stepped in to save the house and restored it.

Residence of Charles Dudley Warner. Hartford, Conn.

How does this weather suit you?

No. 763 Published by The Chapin News Company (Incorporated), Hartford, Conn.-Leipzig-Berlin

Another Nook Farm home was the residence of Charles Dudley Warner, author, editor, and friend to Mark Twain. Supposed partisan politics played a part in the havoc that reached Nook Farm. Since Hartford Public High School had a highway coming through it, a new location was needed and Forest Street was chosen. The Warner home was lost, as were so many others.

It is hard to believe that Mark Twain's home was almost lost as well. Mark Twain built and lived in this house from 1874 to 1891. Family tragedy and financial losses forced him to sell his beloved home in 1903. It escaped demolition and still proudly overlooks Farmington Avenue.

After Mark Twain sold the Farmington Avenue property, it changed hands several times, becoming a school, apartment house, and even a branch of the local library. This view shows the boys who attended the Kingswood School in 1919.

Nine

PARKS, RECREATION, AND LEISURE TIME

Riverside Park was designed by the famous Olmsted firm. It was made up of 63 acres along the Connecticut River. It provided convenient access to the people who lived in the Front Street neighborhood.

The park was a great place to stroll in and for children to play. However, when the dike went up, the highway came through, and the entire Front Street area was leveled, the park was cut off and mostly forgotten. Current efforts have been made to restore access to the river and to downtown once again.

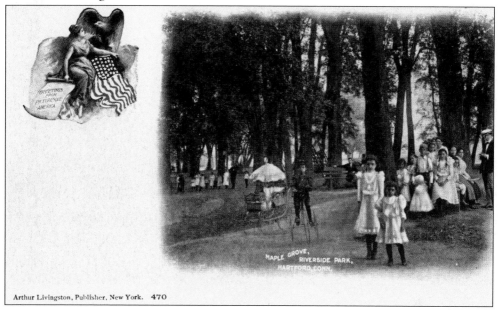

MAPLE GROVE, RIVERSIDE PARK, HARTFORD, CONN.

Arthur Livingston, Publisher, New York. 470

102

The Ravine, Laurel Park, Hartford, Conn.

Hartford had an incredible system of parks that began in the 19th century. In an era called the "reign of parks," public parks were created throughout the city for the enjoyment of its citizens.

Scene in Laurel Park, Hartford, Conn.

Lake in Goodwin Park, Hartford, Conn.

One of the larger parks was the 237-acre Goodwin Park. Another Olmsted-designed park, it was one of the rare ones that was not divided by roads. A golf course was eventually put in to meet the demand of the increasingly popular sport.

Golf Pavilion, Goodwin Park, Hartford, Conn.

Keney Park was the most rustic of Hartford's parks. It grew to an incredible 693 acres. Filled with woods, pastures, streams, and wildlife, it was a great escape for any visitor.

Pond House, Elizabeth Park,
Hartford, Conn.

Elizabeth Park was perhaps the most formal of Hartford's parks. It was a bequest in 1894 from Charles M. Pond of his estate for the creation of a park in memory of his wife, Elizabeth. Their home was used by visitors and staff alike. After much debate, the house was demolished in 1956. It was a sad loss to the park.

Elizabeth Park, Driveway and Flower Beds, Main Entrance,
Hartford, Conn.

215811

Theodore Wirth was the park's first superintendent. He designed a more formal park in contrast to the rest of Hartford's pastoral parks. This decision has given Elizabeth Park the honor of having the oldest municipal rose garden in the country.

THE GRASS STEPS, SUNKEN GARDEN,
ELIZABETH PARK, HARTFORD, CONN.

2550

Elizabeth Park had very unique landscaped features. The Grass Steps were an architectural delight, and there were thousands of roses to behold. Over the years, many of these features disappeared, but happily many of the now 100-year-old roses still remain.

Rose Garden, Elizabeth Park, Hartford, Conn.

When visitors to Hartford's parks tired from all the fresh air, restaurants were the place to go for a bit of refreshment. This one provided not only meals but an exhibit of antique weaponry.

Parades were popular with the Victorians. Flag Day and events honoring veterans of the Civil War were great occasions. This view shows the Cheney Silk float passing Pratt Street, coming down Trumbull Street.

Luna Park was a sight to be seen. There were amusement rides, refreshments, and even a vaudeville theater. The park was decorated with thousands of lights that made the night sky glow.

The place for a spot of tea was the Japanese Tea House, which offered free tea to anyone who played a few games of "rolling ball."

WE FURNISH AMUSEMENT AND INSTRUCTION AT THE BIG CONNECTICUT FAIR.

The Big Connecticut Fair took place from September 4 to 9, 1911, at Charter Oak Park. Aviation was still in its infancy. This biplane looks like it is flying dangerously close to spectators, who seem unconcerned by its proximity.

215800

In 1854, citizens voted for the creation of a city park. Located along the Park River, the park was named Bushnell Park after Horace Bushnell, its main instigator. The Park River was buried to control flooding, but there is discussion of a possible resurfacing. It would be marvelous to see the river restored to its natural course through the park.

View from Bushnell Park, Hartford, Conn.

Several wonderful bridges connected Bushnell Park to the surrounding neighborhoods. The view above shows the intricate Trumbull Street Bridge after an ice storm. The view below shows the Hoadley Memorial Arch Bridge. Both bridges were lost when the river was buried.

The Park River Falls were a treat to see as the water rushed by, headed for the Connecticut River. The large turreted building to the left is the old Elm Street Armory.

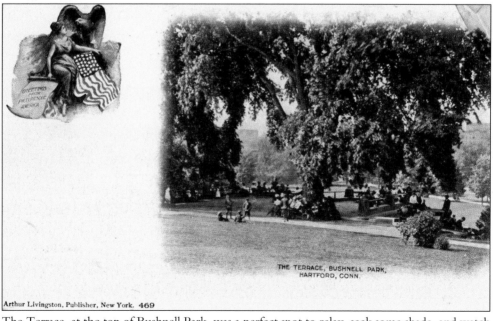

The Terrace, at the top of Bushnell Park, was a perfect spot to relax, seek some shade, and watch the trains pulling into and out of Union Station. It was destroyed in the flood-control project. There are plans for it be reconstructed.

114

ARCH and FOUNTAIN, Hartford, Conn.

The Corning Fountain was built in 1899. It features Native Americans in four different poses and is topped with a hart, the symbol of Hartford. Notice the beautiful array of buildings that framed the park at one time in the postcard below. The Garde Hotel is to the right. Only the fountain remains, restored in recent years.

Fountain, Hartford, Conn.

Parsons' Theatre—Hartford, Conn.

The Parsons Theater was a spectacular place. It stood on Prospect Street and Central Row. There were ornate balconies and was regarded as a first-class venue. Sadly, it did not survive to entertain future generations.

Ten

HARTFORD LIVING

Vanderbilt Hill. Hartford, Conn.

A house that could have been built in Newport was actually a Vanderbilt home on Farmington Avenue. It stood on the avenue west of Prospect Street. The street had many grand homes, but most have been lost. This mansion was torn down and the land subdivided. The gate remains.

Echo Lawn, Residence of Pliny Jewell, Hartford, Conn.

Another Farmington Avenue home was Echo Lawn, built by Pliny Jewell, one of the principal owners of the Jewell Belting Company. It is more than likely that the bearded man is Pliny Jewell himself.

Asylum Street, Looking Towards Depot, Hartford, Conn.

This view shows Asylum Street in its heyday. The street was filled with stores, offices, and apartments. On the left is the Goodwin Building. The building was later gutted. The facade was left standing, and a steel tower was erected on the site.

This is the Bushnell Park side of Asylum Street. People are on the street. The city is alive. These buildings enjoyed pleasant views of the park and the Park River. They are only a memory now.

The Speirs Residence, 800 Asylum Avenue. HARTFORD, Conn.

Asylum Avenue was another street where the well-to-do built their homes. The elegant Speirs home stood at 800 Asylum Avenue.

Sigourney Square—Hartford, Conn.

The middle class also built homes to be proud of. Sigourney Square had a quaint park surrounded by lovely homes. The area has fallen on hard times but has seen some efforts at rehabilitation and restoration.

The Sigourney House was at 1150 Main Street opposite the entrance to Trumbull Street. It was a mix of commercial and residential spaces.

All streets eventually led to Main Street. It was long and broad and contained churches, banks, stores, apartments, and private homes. The street has changed considerably over the years but maintains some evidence of its Victorian past.

These views show the great shopping section of northern Main Street. The view above shows the Richardson Building on the right and the Wise Smith department store on the left. Seen below in a view looking south are the Pilgard Building and Baptist church in the foreground. Farther down are G. Fox and Company and the Richardson Building. What once stood in the foreground is now Interstate 84.

Main Street, looking South, Hartford, Conn.

Very few brownstone row houses are left in the city. This view shows the ones that were built on Elm Street. They faced Bushnell Park and were architecturally pleasing to the eye.

Lenox Court, Apartment House, Hartford, Conn.

B. PIERCE, PROPRIETOR.

As more and more people entered the work force, more apartments were needed to meet the demand. Lenox Court provided ample space for those just starting out.

Apartments sprouted up all over the city to accommodate the influx of new immigrants. The buildings shown above stood on the corner of Buckingham and West Streets. The view below shows the Capitol Avenue area packed with structures. The apartment house at the bottom right is where the Bushnell now stands. Most of this area is now a sea of asphalt.

Wright's Panoramic View of Hartford, Conn. (Copyrighted.) No. 4—Looking East.

Wright's Panoramic View of Hartford, Conn. (Copyrighted.) No. 7—Looking Southwest

This is Frog Hollow, where many new immigrants settled. They worked in the nearby Capitol Avenue factories and became the backbone of Hartford's robust economy.

View of Hartford, from top of the New Travelers Ins. Building, looking East.

We return to the Front Street enclave where Hartford began. From its commercial beginnings to the last days of its ethnic charm, it was a neighborhood worth saving. Hopefully, many lessons have been learned, and continued efforts to preserve what is left of Hartford's architectural past will enrich and be treasured by future generations.

125

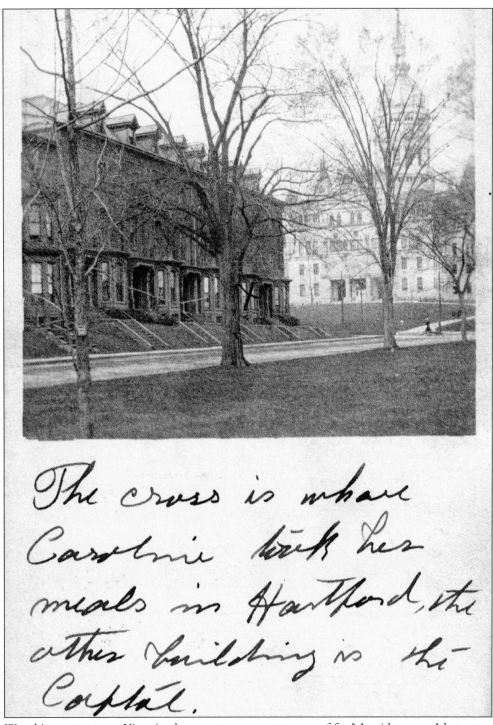

The cross is where Caroline took her meals in Hartford, the other building is the Capital.

Was this an attempt at Victorian humor or a mere statement of fact? In either case, I hope you have enjoyed this treasure-trove tour of Victorian Hartford.

—Tomas J. Nenortas

BIBLIOGRAPHY

Alexopoulos, John. *The Nineteenth Century Parks of Hartford*. Hartford, Connecticut: Hartford Architecture Conservancy, 1983.

Andrews, Gregory E., and David F. Ransom. *Structures and Styles: Guided Tours of Hartford Architecture*. Hartford, Connecticut: the Connecticut Historical Society and the Connecticut Architecture Foundation, 1988.

Elihu Geer's Sons, Canvassers and Compilers. *Geer's City Directory*. Hartford, Connecticut: the Hartford Printing Company, 1911.

Faude, Wilson H. *Hartford*. Dover, New Hampshire: Arcadia Publishing, 1994.

———. *Hartford Volume II*. Dover, New Hampshire: Arcadia Publishing, 1995.

———. *Hartford Volume III*. Dover, New Hampshire: Arcadia Publishing, 1997.

———. *Lost Hartford*. Charleston, South Carolina: Arcadia Publishing, 2000.

Ransom, David F. *George Keller, Architect*. Hartford, Connecticut: Hartford Architecture Conservancy and the Stowe-Day Foundation, 1978.

Sanborn Map Company. *Atlas of the City of Hartford and the Town of West Hartford*. New York: Sanborn Map Company, 1917.

INDEX